Enthralled by Myriad Forms

a tunnel
 carved by millennia

 water

 to see the clouds
beyond the rocks

before the pale blue sky

and

I

crawl up

and towards

 eternity

 reaching for the hand of God

Enthralled by Myriad Forms

Kurtis Tilley

Published by Kurtis Tilley
2015

Copyright © 2020 by Kurtis Tilley

All rights reserved. This book or any portion thereof may not be reproduced or used in any manner whatsoever without the express written permission of the publisher except for the use of brief quotations in a book review or scholarly journal.

First Printing: 2015

ISBN 978-1-329-31501-3

Kurtis Tilley
Greeley, Colorado
tilleysifu@gmail.com

Dedicated

To lovers of writing and poetry.
To lovers of Earth and Art.
To Lovers.

Contents

Beautiful	x
To the Moon	xi
A Star	xii
In the Morning Wilderness	xiii
A Convenient Departure	xiv
Today and Everyday	xv
in my soul are demons laughing	xvi
Thinner	xvii
Blanket of Rain	xix
The Balance of Art/Pain	xx
Process of Growth	xxi
How do Men	xxiii
My Kind of Woman	xxiv
IYME	xxiv
Love and the Educated Heart	xxv
Pain Body	xxvi
Encouragement	xxvii
A Wolf I Have Considered Myself	xxix
A Moment Without	xxx

Repair	xxxi
Winter Nostalgia	xxxi
Morning Breath	xxxii
New Body	xxxii
Gift	xxxiii
The Rose	xxxiii
Listen	xxxiv
A Valentine	xxxiv
Play	xxxv
Endless Void and Mystery	xxxvi
Buddhaverse	xxxvii
Guardian Angel	xxxix
February 25, 2004	XL

Beautiful

birds on the horizon
mountains deep in fog
beetles in the bark of
trees becoming logs
sunlit flowers blossom
evening calls in turn
tears of yore now dry
midnight clouds, Moon a blur
Earth's incessant hum
crashing waves polish rocks
evergreens and annuals
playful romping baby fox
sight sound and savory wine
taste smell, a sense of time
child's tears on a mother's breast
mommy's fears and a father's jest
all alone for many miles
walking many tracks
forcing smiles for a guise
makes up whatever lacks
sleeping in silence
stillness of night
silhouetted female façade
thunder when the flash is gone
a floating fish in an empty pond
burning trees for light
through the day, and all the night
one cannot claim what's beautiful
is always ever wrong or right.

To the moon and back again

The straps that bind the mind in time
allocate the hands to find
a tool to fool the drool
that tends to bend the fire inside
When he had a lot to say
nary did he speak
When we had a spot to play
he turned to hide and seek
For as we spent and stared ahead
our eyes alone but for each other
he went and dared to shed his skin
to try to find another
Alas he's back and to and fro
he tries to pry apart
your eyes upon his lover's
mine upon your heart
He takes the jeers
and wants and fears
my look to fall on him
but yours are mine
mine are yours
and we collapse again
So through the tune and
to the moon
the stars that shine so bright
he screams and cries
just for my eyes
to conceive his fragile plight

A Star

So free to be
of Harmony
Lights and Laughs and Love
to give and get
and not Forget
what it is one does
to make a Merry smile
upon a Lonely face
a Word to walk a Mile
a Heart to set the Pace
a star so Bright to Light the day
and give Life to all that Breathe
a star to Twinkle in the night
when all the Light should Leave
yet should the day ne'er Return
and should the Earth simply Burn
Withering in Humility
I'd Ask a Star
to come From far
and light the Way for Me.

In the Morning Wilderness

there is a soft crackle, Twigs below my feet
the Shadows dance before my face, the Sunlight is discreet
Birds buzz{Chirpingly}
while Willows whisper dreams
the Flowers greet my senses as i walk along the Stream.
 little Black Bear take my hand and lead me to your No Man's Land
 where Eagle teases Rabbit and Wolf dances in the Fields
there are no men to bother me as Leaves caress my cheek
while all the Spider webbing shimmers, assuring white and sleek
 Doe, Deer, Elk, and Fawn
 wander like children in early Dawn
as I lay to go to sleep, the Rain my peace and calm will keep
all the Animals abound, come to lay me on the Ground
we close our eyes to see the Skies forget and disappear around..
the Dark is a warm, quiet, wet Sand between my toes
Water ripples waves of black fingers painted Rose
 {Charmingly} the Darkness speaks
 (rhythm left of melody)
 partaking things afar and great
I lose my mind and tell of Dreams that freeze my Hate for Pain
(warm my Love inside)
warm my Heart, untangle knots tied by my nervous brain
I smile as my back relaxes; Water in my Soul
wash my sins. my dirt, my blood and turn it all to gold
"go back to sleep" my mind repeats, I close my eyes and fall
down the Water through to the end of this tensile body shawl
here I am furry friends who've protected me from Rain,
now that it's gone I shall wake up, my feet are dry again
Kiss me goodbye, with Joy I cry, my Happiness is (Back
through the woods I shall walk)
With nothing on my back.

A Convenient Departure

I am light in a vacuum
 I'm a mold for my person
 I'm the means that you long for
 You need me.
 Like I do.
I coaxed you here through pleasantries
 catered to outrageous pleas
 Your vacuum let me down-
 it's so convenient to leave me be.
I give shade in the summer,
 I gave you Life,
 I gave you me
I sheltered metamorphosis,
 You need me
 like I do.
I sat you down on cushioned seats
 I built your house
 I treated you weak
 Your vacuum brought me down
it's so convenient to leave me be.
I let you strayfrom my nest of love,
 never respected
 never expected
 to be seen from above.
Where I was; i need you-
 Like i do.
Just keep with me a while more,
 You bring life to so many things

Your need, shelters me

 I need you.
it's so convenient to leave me alone.

Today and Everyday

Losing Touch

 I feel the foundation of WHO

 [AMI] I am

d if f u s e

 This whole reality is

make Believe!!

 Senses - mind - a deception of being

Life... "fake plastic" trees

 Help
 Help.

 This, a silicone lie, shielding me
 From chaotic disillusion

God,? where do I begin.

in my soul are demons laughing

 demons

 masterfully crafting

a sanitized lobotomized

 chilled-to-the-bone

 shameful

 w h o a ------------

 this roller coaster shit me
 hit me
 have me
 hate me
 love me hurt me

O H H! ---

 I

 Hurt those I

 Try to love.

in my soul are demons
 laughing

Thinner

Deep within the hollow tree
 where darkness is everything
and the world, alone, comes to stop
 Come inside, here I lay.

I'll be your guide and you my guest
put aside and lay to rest
open eyes that see the best
 Have my time and my test.

I know this, it is my home
 every crack and blade and stone
and the world, alone,
 Here, comes to stop
 stop on by.

I'll be your man and you my girl
together fight this lonely world
blood of Ruby, eyes of Pearl
 flowers at our feet unfurl.

I did not wait within the dark
 for another broken heart
as I, alone, went there to stop
 and you came, all the same
I lend my hand to you my friend
 by my side we'll tread the sand
through the crowded hillside climb
 to not get lost in the speed of time

Out in light
 and air
 and sight
To grow alone, try as I might
the world as one shoves me back
 I get thin.

I'll be your guide and you my guest
though leading blind I'll do my best
my soul exposed outside my chest
 crying out to let me rest.

Don't run or hide, my patience slims
I gave up comfort for a whim
I silently let the living work
And thinner and thinner I become.

Don't fret or fight my intent is good
I just try to please, and should
I quietly let the thinking speak
And thinner and thinner I become.

But where's my voice and where's my laugh
where's my famous taste and class
my jester and my bureaucrat
my lover - and my friend at that

I grow thinner and thinner and thinner
I grow tired and hurried and rude
I get angry and sorry and nude
to the world within my time
I have to get better and I have to get brave
I have to lay in the bed I've made
I have to sleep and I have to eat
And I have to treat you right
All the time.
 All of the time

A Blanket of Rain

I use a blanket of rain
to dry my tears
to put on my head hide from my fears
to wrap like skin
to save me from stares
to cloak my face pretend I'm nowhere.
I use a mouthful of rage
to bury despair
trembling lips to prove that I care
I use handfuls of face
to darken my eye
to dam up the rivers that form as I cry
my knees to my shoulders
connect with a tie
that binds in my feelings so here I may lie.
So bring all the fools
my bastion they'll try
to ascend to collect me, survive or die.
I use this blanket of rain
to soak up my grief;
in these pools of tears, on this bed I sleep.

The Balance of Art and Pain

For all the beauty within art
it seems an artist is in pain
it seems
art is so smooth and pleasing
the artist enchanting and detached.
Why amidst pureness and glory
has an artist so much angst?
Is pain what makes artists strive for the beautiful?
Is it beauty that makes art so painful
for Truth can be so much less?
Oh but happiness is surely expressed
as well off artists are surely depressed
while the poor and fighting few
it seems
are still content with nothing new.

The Process of Growth

 My friends;
 these mangled, mulched and

pulped TREEs

 this INK.
 I think and you copy my thoughts
 you never chastise my lost
 teary eyed heart

 in part, though
 I feel my greatest friend
 Can't comprehend
 Can't respond
 Can not bond,

but that is only common sense.
 Can I ask an inanimate
 to animate
 compassion?
 Can I muster up the courage to
 keep on askin?
My words are slurred to the common herd
but I feel free like a bird
 in a zoo
 designed to remind
 the encaged what is true.
In my solitude
my inability to confide,
 a Dark Side is

drowning my Light.
 here, now,
 in Babylon
my luck is gone
an insignificant raindrop
 on a drive
 an excuse for life to survive,
asking for abuse to stay alive

 smiling on the outside
 dying on the in
 and, oh, I don't know where to begin
 but here's where I am
 and here I remain
 growing from the pain, from zero to gain
 waking each day
 occasionally letting the rules bend a n
 d B$_e$
 nd and Bend.
 And I feel this trend
 might end
 with a Break.
 So consciously awake, each step I take – Forwards
 more towards progress and purity.
and I, so young,
 rely on
 mind and tongue
 fingers and fun
 heart and lung
 to keep me moving
 so I keep grooving
 with it.
 and this is the process of Growth. I hope.

How do Men

How does the sea, so gracefully,
comfortably house its turmoil?
The breaking wave, and deepest grave
minerals and oil.
How do the clouds roll softly by
on days of raging thunder?
The light above cannot break through
the hearts below, asunder.
How mountain peaks, sharpened rock
slice the water bodies
so rain does fall as snow and ice
smoothing jagged surface
and little souls upon the plain
admire higher purpose.

How does man breathe deeply in
to face the dark and deadly,
does he maintain faith and fear
balanced at the ready,
or is strength of woman close at hand
in heart and soul and inspiration
how a man can safely stand
on the shores of warring nations.

How does fate awake insight
within beings born of light
defining void in search of Tao
with preconceived conditions,
whereupon the void itself
defines form revolving,
eternal soul becomes whole
deriving peace from calming.

My kind of Woman

>
> is Proud to be a Woman
> Proud to be a human
> Proud to be Herself.
> stands tall and doesn't slouch
> smiles and doesn't shout
> has it all figured out
> And
> knows she's
> My kind of Woman.

I am

[**Iyme**] taking a trip to another realm
one of experience, where everything stays the same
where planet and sun continue to move
 bugs and people continue their lives
 And I
 Am

There exist levels, like bubbles
 little and large
 isolated and encompassing
 And I Am
Becoming
 them all. Internally small
 smaller until I am

 None
While still expanding out towards the sun.

[I gave my heart away / it is too much to be contained]

Love & the Educated Heart are the Same

Depending not upon the delight of eyes on your frame
Depending not upon the sensations of skin
 or within the sin and shame of some game,

But upon the myth and metaphor exciting the brain
for Divine Masculine and Feminine united again!

Love's writing no end to a story grown between friends
like lying, together, naked in bed
transcending motion and contact forever instead
of fulfilling desire to sever the infinite thread
 of Satori envisioned within our heads.

Love and the conscious mind are the same,
your being encourages mine to be sane
mindful and aware of pleasure and pain
like leaves on a tree enduring the rain
throughout the night, knowing, the sun does remain
to cycle around and around and around.

Love and the willful soul are the same
expressing that risk is Wisdom to gain
experiencing Courage, Honor, and Strength
allowing our primitive beings to play
and teaching the Tigers of the Heart to be tame.

Together a Virgin state is attained
through Purity and potential arraigned
to counter the falsehood of social constraints.

Love is the union of three sacred gems
body, mind and a start without ends; All Knowledge
the circle, the union of spirits will blend
and God's holy hand will reach out to mend
all wounds over time so that we may send
our love to each other and back out again.

Pain-Body

She speaks,
though it isn't her.
She acts,
though she is reacting.
her heart is crying
her voice burns, her love dying
her body thriving on emotion
this commotion is the simple notion
her mind is the deepest Ocean
she is lost in.
Tossed in and kicking
tumbling in waves of feeling
and when she breathes
suffering fills her lungs
while her tongue lashes out at him
he waits for her
to come within reach
so that he may lend his hand
becoming land for her to stand upon
until she finds her ground
And the sound of screaming
is her pain body dreaming
from which she's woken
only by patient believing.

EnCOURAGeMENT

 thoughts of mortality
circumnavigate my mind
returning in fresh new ways
there is only one thing i have right,
that is right now. i am.
Until these thoughts manifest, i am.
Until i end, i will
Be strong, Be comfortable, Be open
i birthed a Universe
it is overtaking me
i am treading in the Ocean of Samsara,
look, i am smiling.
What am i but a pebble on the path?
Pushed along by passer-by people
I AM the path. Tao, the void
solid and round
smooth and grounded
I am because I choose to be.
That, they don't know, or haven't figured out
below me is my rock, my teacher
and occasionally one settles
learns as dust on my surface.
Yea I am aloft in the Ocean of Suffering
a stone on the Path
a Teacher and a Student
Mortal and Infinite
my fears and doubts rumble in the deep,
despite my wisdom.
To spite it. So that I may never stop
Growing and Learning.
I am free, limited only by caution
Human. Trying, Failing,
succeeding. Surviving.
Soon to be sweating and striving
to improve upon perfection, life
in all of its glory and strife

the smallest step forward is
the Greatest leap of all
that is the nature of excitement
just to do, and to notice
what has been done, to see what can come
perfection, miracles.
mortal and infinite
specific and indefinite
exact and impermanent
it is Love, I am loving it!

"A Wolf I have Considered Myself

but I have eaten nothing
and am tired from standing out" Lakota Song

A wolf I have considered myself
I have stood by upright
as my brothers and sisters run.

Alone I have endangered myself
belonging to nothing and starved
frightened by eyes that see through my thick coat
and proud of scars that mar.

A wolf I may once have been
a teacher akin to Earth
yet now I lay open and panting
 see my form captured and tame
 believing my teacher is made
 from the burns and the blood I spilled dreaming
 the wolf on my skin I am painting
 is the Wolf in my heart I can save.

A wolf I have considered myself
no pack I may have, has had me;
a tree in a meadow that's burning
a star in a sky that's falling
a Dog at the end of its leash.

A wolf I have considered myself
But now I am naked and howling
tired of pretending I'm not.

A Moment Without

only in moments do we each see passing
newtonian judgments of a self-made mastery

a controlled health blast of nastily compacted
qualifications that never held up to or acted

in favor of the sense itself that fast tracked
flattery of the wealth of so miniscule matters

one of which would quickly shatter the ideas
of primevil patterning mixing Ave Maria

only in void can be expressed form
like sitting still in a cloud of flies in a dorm

hearing sounds of footsteps storm
by the door, bass beating on the floor

whilst mind and spirit disappear
only to be reborn with equanimity

self-made judgments quickening
spiraling into thickening, beckoning

rejection. Alas Dejection

within the soul is ample protection
from a Calm, mild selection of perception

the filter for letting stress in and out
here found is a moment passed in "without."

Repair

Oh age and passing days I work and weep
how could I let my heart be full of sighs
I wish only for peaceful times of rest and sleep
to help recover tired hands and eyes
might I but kiss my love upon the cheek
her to reciprocate upon my lip
my arms do want a heart to hold
my heart a warm embrace to sip
tender love in a moment's lost
as time does hurry on
how I dream to pay the cost
of singing one eternal song
of holding to my breast that love
that fleetingly does come and go
only in my sullen thoughts
can such a thing be known,
but with a heart surrounded
concern and love declared
I am in part astounded
at my weariness repaired.

Winter Nostalgia

soft vibration of leaves
brushing whispers in the breeze
autumn sneaks quietly in and out
as Winter penetrates thick layers with ease
in the stillness of the Frosted Night
clouds bring crystals of frozen moments
blanket the sky like a warm embrace
holding in the city light
 A sepia tinted nostalgia
that reminisces of warmer times

Morning Breath

the breath of the morning
dew drops delicately form
 on the softest tips of quietude
not even birds dare break the silence
 the day unborn, its potential unrealized
 its burden unborne, successes unstifled
in this moment, stillness,
 One may clearly see
how to purposefully
continue moving forward
 holding the pieces together
 with love and patience.

New Body

this, being used
 a newer model
consequently the mechanics of which
 needing some repair
stiff in the clutch
 fuming carburetor
but purring
 with a deep need to be driven
 with each new ignition
 rumbling with pride
a history of breaking down
 and consistently returning
stronger and with new hope.
-solidly framed
 powered by a stud of horses
this,
 one machine
embodying spirit and innovation
travels a road less travelled
succeeds in autobody graveyards
 keeps pace with whirring
rice burning punk models
Oil, Fuel, and drive it with deep satisfaction.

Gift

She walks upon a gifted Earth
of sky, beast and land
she floats as if she has self worth
more than one could understand
to move with such a depth of mirth
a wellspring of Love at her command.

How does she glance in such a way
illumined BeautyandGrace
a gift within one's day to day
her light inspires impassioned chase
can a glance or word softly conveyed
have her attention soon replaced?

In her Heart and on her Mind
 softness patience eloquence
a touch of stars, of being kind
a rarely noticed innocence
let it be known that one may find
This a person of significance.

The Rose

From whence the Earth does sprout and grow
of stem leaf and blossom
'tis just the surface of the Rose
the depth of which is awesome.
Through generations venerated
symbolic images generated
poem and picture lovingly created
This is just that Rose.
the sight of which makes the heart twitch
the scent beguiles the nose
for centuries to come and gone
This is just that Rose.
and in that grace of time and space
as every color shows
there are few things to hold the place
of This, that sacred Rose.

Listen

What is the speaker of the Heart
that earnest sense of self
what value can be made to hear
what silence can be kept so dear
what listens to set those apart
as if it were longevity
those stewards of the mind
deliberately create
ethically deliberate
as if to live integrity
as if the two would bind
and trust a note from string be strummed
and trust a beat from dream be drummed
as love flows through and on
for the best we can hope to achieve
is that our work for them will be
long after we have gone.

A Valentine

Might I but in a breath convey
or from a well of ink express
depth more than a dossier
a sense of Truth to acquiesce
I'd lay before thee Light of Lights
though I but made of Dreams
but dreams so lustrous in the night
therein quality redeems
so Days by day my heart confess
such words are safe to share
you are a treasure and no less
a paragon without compare.

Play

let us be such, You and I
like petals on a silken bloom
a strand of touch across the eye
a whisper 'cross the room
let us play, as boy and girl
like sunlight on the wind
a kiss to make your tip-toes curl
sense of the heart grinned
let us soft, brush minds tonight
like foreplay for the soul
a taste of love upon the lips
like Clouds caress and roll

Endless Void and Mystery

What space has form to belong?

Wherethrough wandering clouds and memories
lifetimes of feelings can dream.

A heartsong sings;
 somethingspecialsomewhere exists

and for this we seek light in the void
like painting the clouds with prayers
and filling the seas with tears
all so we can find our way home
to look up and wonder
whatever can I become?

my heart moves, it has a rhythm
my Spirit sets tempo and Time
collects stories of mourning
as Love edits the rhyme

each moment a nectar like honey
each thought the purest of thoughts
each day enlightenment beaming
each night drift to the Gods
turn ourselves over and offer
to the Sun, the Moon and the Stars
a spirited palette of color
a purpose to know who we are

like flowers awake in the summer
the magic in autumn's demise
an unfathomably beautiful future
I've found in the depth of our eyes.

Buddhaverse

The Golden Hand, cupped
carries water cooled to cloud
poured upon the peaks of
precious mountains all around,
in the perfect act of flowing,
by the sacred act of growing
sprouts beast and ample forest
manifest upon the ground.
The hands of greatest giving
held by those aware of living
motion, "Come with me
to this place of light and sound."
"Open up your eyes and see
these colors that abound,
open up your ears to hear
the music spinning 'round."
flowers bloom to bless this dirt that is Earth
adorn your soul with joyousness
wake within the Buddhaverse.
consciousness blooms to bless this moment of birth
adorn your mind with peacefulness
wake within the Buddhaverse.

a trillion treasures await when you renounce their worth
adorn your body with nakedness
wake within the Buddhaverse.
Behold a set of glowing hands
holding out their palms
offering everything there is
beyond the standard alms.
giving everything they have
to everything that asks
and never asking anything
that they could not give back.
Like the Golden Hand takes the water from the sea
giving to the empty plain, life and all there be
in a perfect cycle without a start

this will not have an end
as all flows in a circle and begins again.
The human heart is not so far,
it simply does not see
it needs our eye to open wide
to give relentlessly.
Compassionately .
Unconditionally .

give peace receive love, give love receive peace.

Guardian Angel

Up on Yonder Hill I glared
as, back, Ye Ol' Sun stared
I but a son myself
rested ass and shared
the grass, dirt and blossom
fresh breeze scents and then some
soft tree whispers telling
eon stories awesome
O' glory is to Father
as grace belongs to Mother
I but a son myself
whisper to another
the names of my creators
those to whom I relate
and I in such good health
so distanced from cremators
carry with me angels
through whom me
 my Lord protects
One Angel He sent in earnest
for my time of unrest
'Twas Angel fathered spirit
when body and mind were true
who embraced my soul and revered it
who taught me, gave me new
views of the world that I live in
and opened the doors to my self
with wisdom compassion and challenge
to find faith o'er material wealth.
As angels just serve they might not
have all of the knowing for why
but what is unconditional
is surely indestructible
and service to God reminds
that love is the foundation
of relationships and trust
of fathering, duty and care
while I but a son myself
am grateful you were there.

February 25 of 2004

-Fifty two stories into the leaden sky,
 a penitent ape recites:
"Oh Lord, through thick and thin
I've been with you throughout
Oh Lord, I love you so
I pray to you without
Oh Lord, the people die
My hands o'ersee the act
Oh Lord, the people cry
My feet are slow to react
Oh Lord, forgive your son
For I love you so
Oh Lord, forgive your slave
For I make you so"
- a plane behind him crashes, the wind a violent storm. The ape grabs a flagpole, stolid and worn.
of course Hitler did not know his tail had broken the pole,
 he did not see the trinity fall slowly to the floor
with an American flag waving triumphantly in the back, the American plane brought down.
The wind portrays history, turbulent and ever changing
 the cloth internal pride.
-this building, as our ape friend who sits atop alone,
 is full of empty windows and a broken wall of stone.
the bricks we see asunder as the ape balances still,
 we hear the heavens call to him; a man, a voice, a chill.

"My servant hath thou devoured man?
Men hath devoured thou.
Your parentage hath been thou hate,
Your people are your cow.
Becometh of your sovereignty,
You friends have found you foe.
Becometh of your sovereignty,
Your foe you've come to know.
Becometh of your sovereignty,
Your heart be blackened still
Becometh of your sovereignty,
Of men you take their will.
Repent! My son, forgiven not
Repent, your soul is mine.
Repent! My son for God is not
To whom you pray in mind.
These people are just people son,
They pray to me as you.
If my name be different,
Still it is nothing new.
My son a name means nothing,
long as I'm credited
These people are of my son
All are penitent.
A life represents, my son,
Of how a man you are.
A love represents, my son,
Of how your heart is far.

An Islamic man once prayed to me,
"Allah! Give Peace and Love!"
A Jewish man once prayed to me,
"Oh lord! Make Peace and Love!"
A Christian once prayed to me,
"In Jesus' name I love!"
A Hindu once asked me,
"Brahman, make Peace and Love!"
A Buddhist asks me not,
Yet cultivates the two.
Egyptian priests have cried to me,
"Ra, Osiris, Horus! Peace and Love form you!"
Indigenous folks of every land
Have found my hand within their hands
Can you now understand,
It is not how you believe
Call me what you want and will,
Just be Love and Peace.
Man hath translated through his actions,
Hate and Evilness.
I sit atop my chamber high,
Hearing pleas for happiness.
What, my son, am I to do?
Take your will again?
I shall not intervene, I shall not intervene
My son I hear you kill for me,
I shall not intervene.
Believe me, my only son,
I sent to help you learn

You put his body on a cross
few listened to his words.
If I could I'd cry for you
For your beliefs I let you keep,
As for what you do to men
I'd sit eternally and weep
You impose your beliefs
Upon those of not,
Killing them for their ways!
Hate them all you want,
But I ask you leave them be
Interfere not with others
Else interfere with me."
-The light left the monk's face, the plane hit the ground.
The shockwave knocked him from his place, and his head fell off without a sound.
-Observe the limp lifeless body, laying to rest on the trinity
as all creatures live in grace, life and death do have their place
He couldn't have his way; the plane, the flag, the building-side
He lost his head, off the edge, and left his body behind.

 While cautiously in a café below, a young man wrote everything down. Alone, in a building sized
to withhold an entire city, he sat. Unnoticed by passersby, a witness by himself, of himself. He burned his paper at the end, lit the curtains, the wine, the building. He set himself alight, became enlightened
and life went on in Denver.

Acknowledgements

I would like to thank my Parents, Teachers, Friends, and Love for their enduring support of my imagination and belief in my potential. Thank you to my creative writing group for your generous use of the editor's pen…

www.ingramcontent.com/pod-product-compliance
Lightning Source LLC
Chambersburg PA
CBHW072301170526
45158CB00003BA/1144